The Magical Reindeer

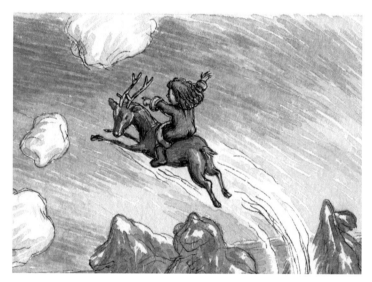

A Beautiful Story for Christmas

Written by David Ocasio
Illustrated by Giora Carmi

To order additional copies of this book, contact:
Xlibris
844-714-8691
www.Xlibris.com
Orders@Xlibris.com

The Magical Reindeer

Welcome to Santa's first Christmas - with Kassandra the Angel of Christmas and her sidekick Eddy, Santa's first ever flying reindeer, who now reigns as the guardian of Santa's magical reindeers. Here now is their very first adventure....

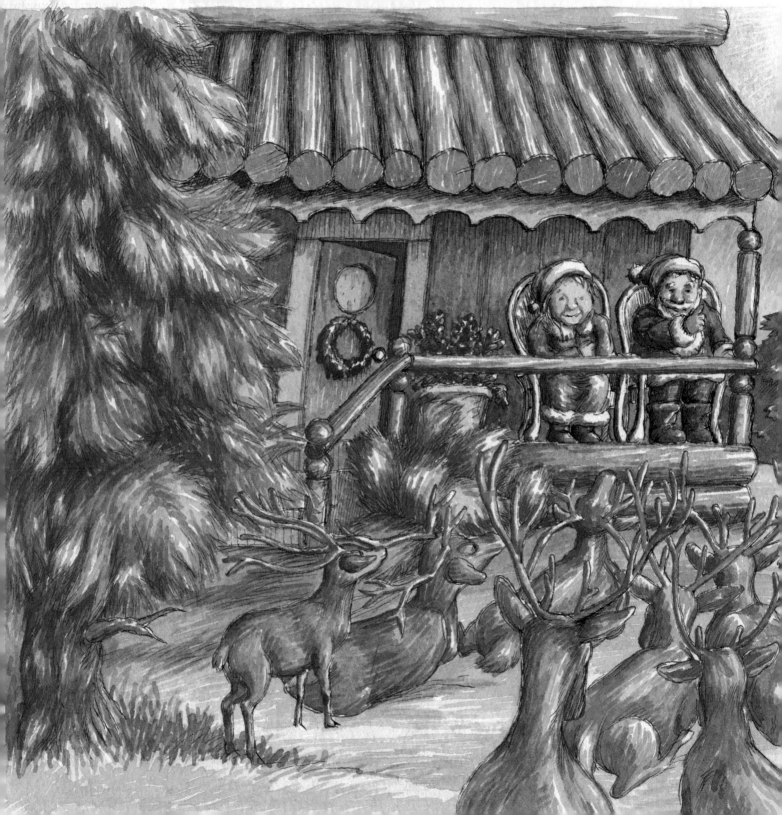

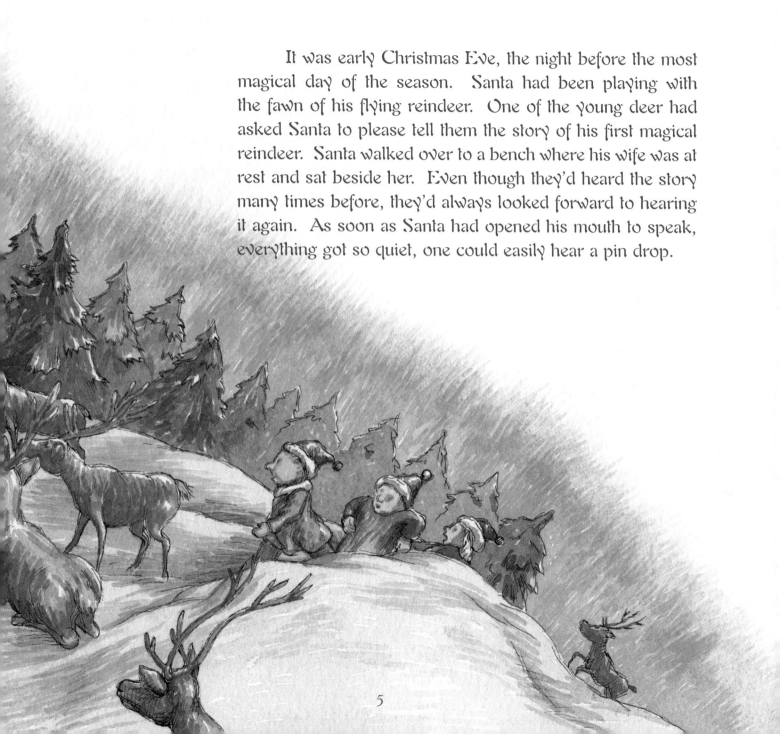

It was early Christmas Eve, the night before the most magical day of the season. Santa had been playing with the fawn of his flying reindeer. One of the young deer had asked Santa to please tell them the story of his first magical reindeer. Santa walked over to a bench where his wife was at rest and sat beside her. Even though they'd heard the story many times before, they'd always looked forward to hearing it again. As soon as Santa had opened his mouth to speak, everything got so quiet, one could easily hear a pin drop.

"A very long time ago in a forest not far from the North Pole, a young deer was wandering through the woods when he stumbled upon a lost little girl. He noticed a tear in her eye, and wondered why she could be so sad on this most magical day of the year. So he walked over to her hoping to bring an end to her sadness."

"Hello little girl, my name is Eddy. What's yours?" he asked.

The girl just stared at the deer in bewilderment.

"Oh! Gosh! I forgot, Deer can't talk to humans," Eddy thought to himself. When suddenly, a streak of light lit up the sky, and an angel appeared. Eddy breathed a sigh of relief. Could the angel have been sent to bring an end to her sadness?

The girl, not able to see the angel began to cry.

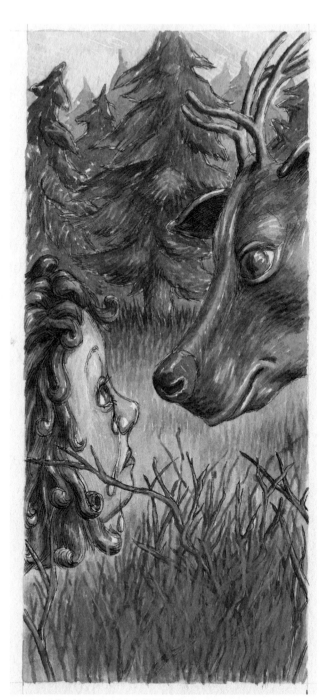

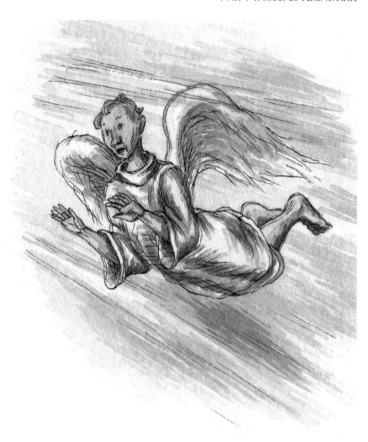

The angel, remembering that humans could only see them for divine reasons became confused, not sure of what he should do. Eddy turned to the angel and said, "Are you really an angel?"

The angel pointed his finger at the deer, and Eddy arose high above the trees.

"Wow! This is really cool," he shouted out.

When the girl saw the deer rise into the air, she smiled with wonder and delight. As the angel lowered Eddy, the girl asked if he could help her find her way home. Eddy looked at the angel and said, "Makes sense to me."

The angel stood thinking what he might do as Eddy asked him his name.

"My name is David," answered the angel.

"What do you think of the little girl's idea?" asked David.

"I believe it is a great idea," Eddy replied.

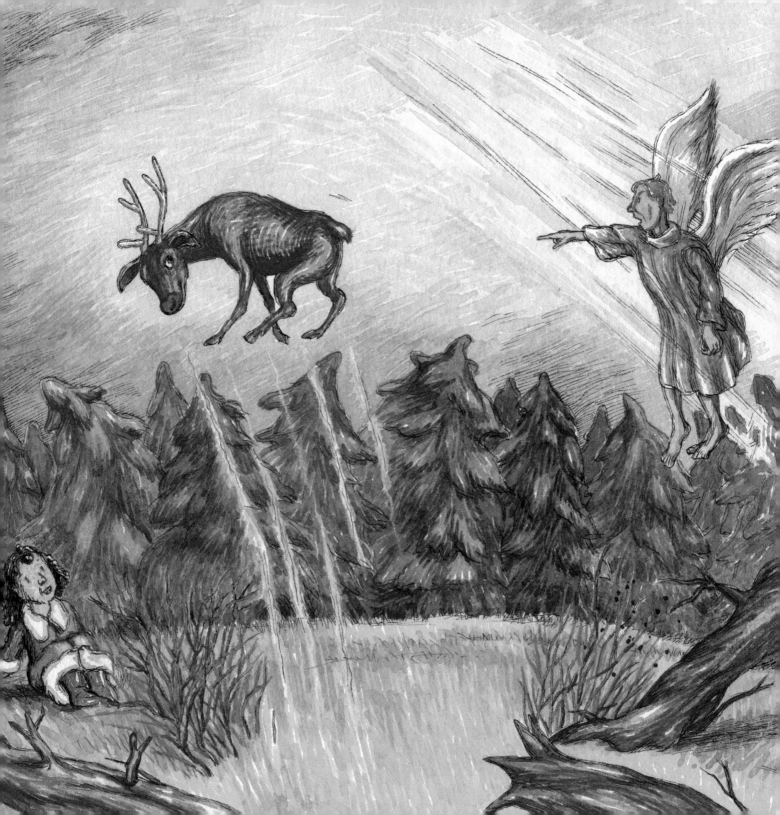

"I don't know, Eddy, it doesn't make sense to me."

"You know what the problem is, David, you're a worry wart. You worry too much. Just look at it this way, the girl finds her way home, problem solved.

"I'll tell you what I'll do, Eddy. I'll grant you the magical power to fly for two hours, and only two hours."

Eddy knelt down, the girl climbed onto his back, and off they flew, way up into the sky.

Eddy and the little girl had a wonderful time as they flew from one house to the next. Finally, when they got to her home, she pointed to it and said, "Look, that's my house over there."

As they neared her home she said to the deer, "This is so much fun, why don't we fly for a while longer."

Eddy thought to himself, "Let's see, David gave me the magical power to fly for two hours, and it's only been a half an hour, makes sense to me."

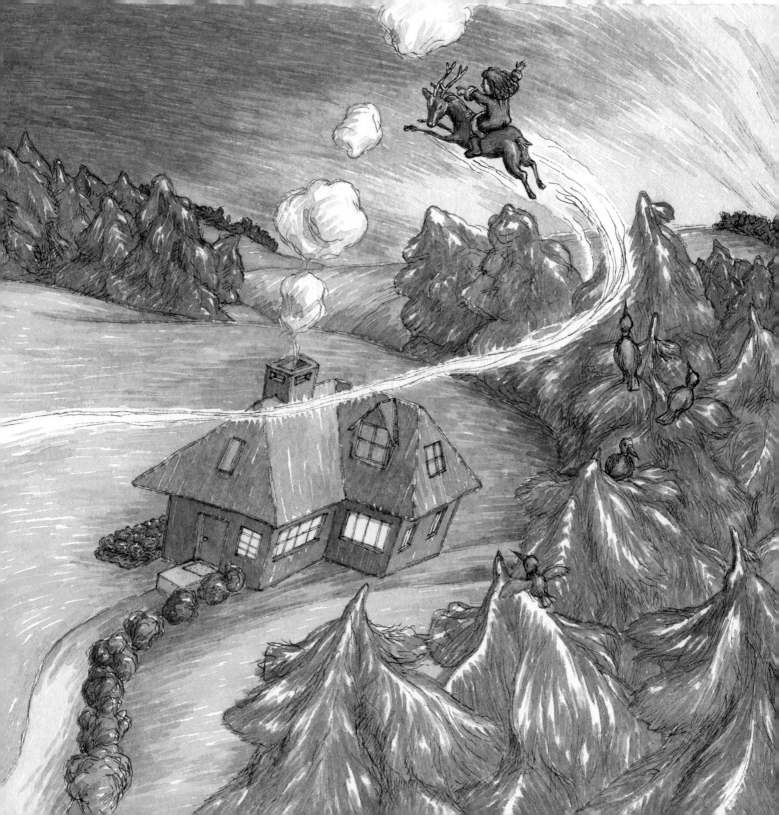

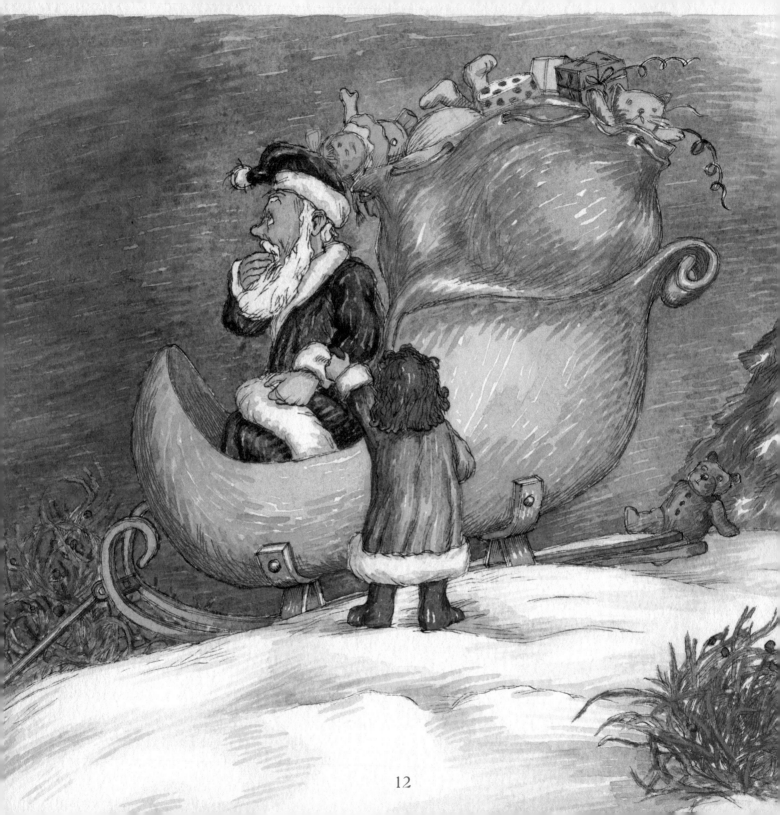

Soon after, they found themselves over the North Pole. As they looked down, they'd seen an elderly gentleman with a large white beard, and dressed in red. He was sitting in a sled that was stacked full of toys. Out of curiosity, the girl asked the deer to land by the sled. She walked over to the man and noticed a look of concern on his face.

"Is something wrong, sir?" she asked

"I have a big problem, and don't know what to do," he answered.

13

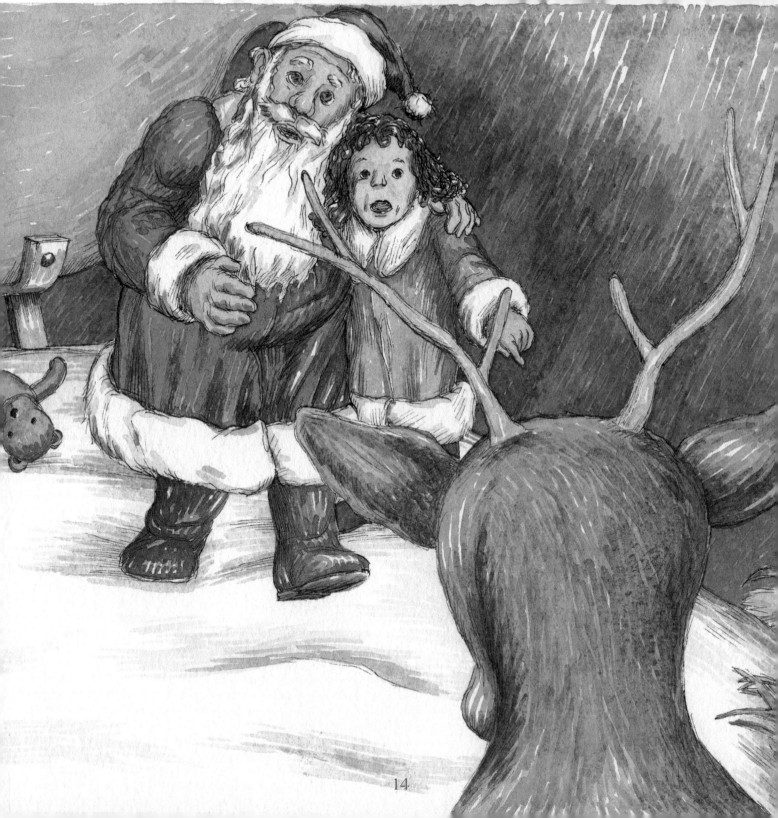

"So, what is the problem sir?"

"My elves and I have spent the entire year making toys to deliver to all of the world's children, and haven't yet figured how to deliver them."

"That truly is a very big problem sir."

As Santa scratched his beard, the girl asked, "Is there anything in that bag for me, Mr.?"

"There might be, have you been a good girl?"

"I've been the goodest girl ever in the whole wide world," she answered with a great big smile.

As Santa continued to think, the girl stared at him with great curiosity, "Why are you dressed in red, and why are your whiskers white, Mr.?"

"Because I'm Santa Claus, that's why."

Santa asked the girl her name.

"My name is Kassandra," she proudly answered.

"And why are you out so late, Kassandra?"

Caught totally off guard by Santa's question, she pointed to Eddy and declared, "Because that reindeer was supposed to take me home, and he didn't!"

"Don't believe her Santa! I've been framed! I just came along for the ride," Eddy shouted in his defense.

"I suppose she had to twist your hoof," Santa said to Eddy.

Eddy thought to himself, "Wait a minute, this guy isn't supposed to hear me, he's a people."

But little did Eddy know that Santa was no ordinary human. For Santa had been especially chosen by the angels to bring joy and happiness to all the children of the world.

Meanwhile, the angels were preparing to celebrate Christmas. In the midst of the commotion, Linda, the angel in charge of handing out assignments approached David. She asked if all was well with Kassandra and her parents.

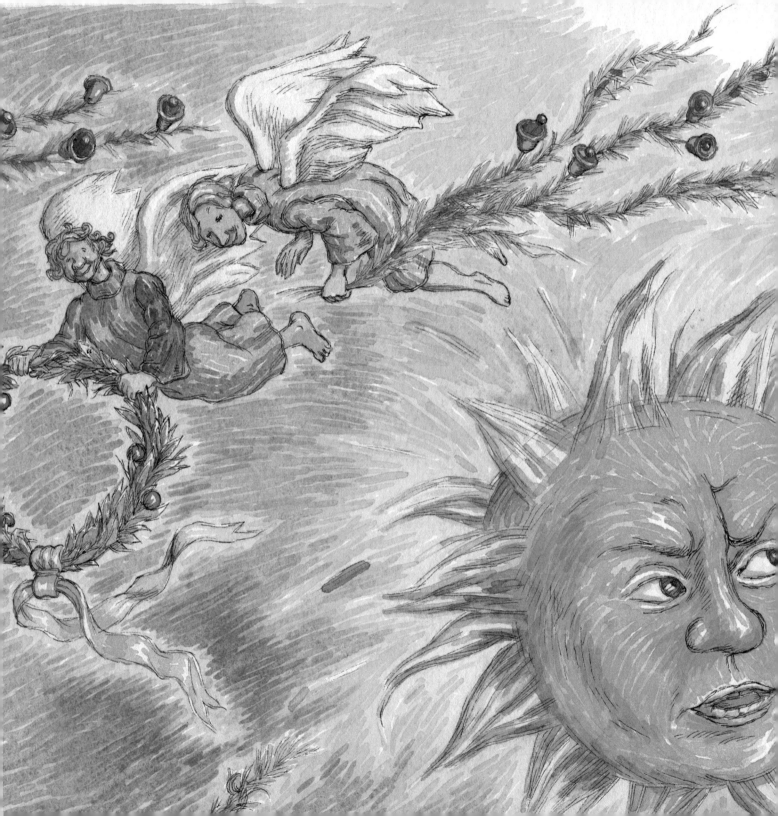

Is something wrong, Linda?" he asked.

"Do you remember the deer you'd given the magic to fly to?"

"Is there a reason for you asking me?"

"It's just that Kassandra's parents are home worried sick."

"You mean she's not home yet?"

"No David, she's not."

In a flash, David rushed to the North Pole.

When he arrived, Kassandra screamed out with excitement, "Look, it's an angel!"

Eddy, knowing that he shouldn't have done what he did, attempted to sneak away.

Santa noticed what he was up to and said, "Are you going somewhere, Eddy."

"I was just looking around, Santa."

"Santa, why is it I can hear the deer speak, and see the angel?" asked Kassandra.

"Because we are very near Christmas, the eve before the most magical day of the season, Kassandra," Santa said to her.

"Gee Santa, do you mean that if I wished for something, that wish would come true?"

Santa laughed out loud and said, "So what would you wish for, Kassandra?"

Kassandra looked at David and answered, "I would wish to have the wings of an angel, that way I could fly myself home."

Santa turned to David, David placed his hands in front of his mouth, gently puffed magic dust in her direction, and wings grew from her back.

"Those wings will only be with you until you've found your way home," David said to her.

"Just like you, I too will be able to fly, David."

Kassandra took one step forward and fell on her face. She flapped her wings, but all Kassandra managed to do was dig herself deeper into the snow.

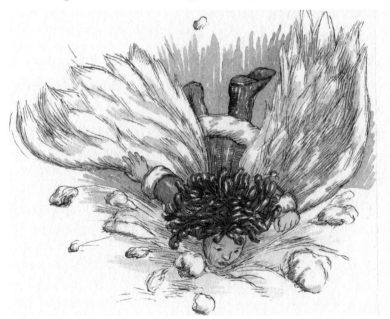

David quickly reached over, picked her up, and as he did, a blob of snow landed on Eddy's face. Santa pointed to Eddy and said, "Look, it's a snow deer."

"Ha…Ha…and ha," Eddy responded causing Kassandra to giggle.

David picked up some snow and sprinkled it over Kassandra's wings causing them to melt away. Disappointed, Kassandra asked David why he removed her wings. David explained that Santa would be delivering toys to her house, and he could take her home at the same time. Santa reminded David that he had to be on his way, if he was to deliver everything before morning. Santa and David began to discuss the matter while Kassandra got an idea of her own. So, she tugged on Santa's coat in order to get his attention, "What is it, Kassandra?" he asked.

"I know what you can do, Santa!" said Kassandra with great excitement, "Why doesn't David give Eddy the magical powers to fly again?"

Eddy, excited at the prospect of being able to fly once more, turned to Santa and said, "Makes sense to me, big guy."

David reminded Santa, that, if Eddy would have done what he was told, Kassandra would already be home.

"Might I remind everyone, it wasn't my fault," Eddy protested," If Kassandra wouldn't have tricked me, we wouldn't be having this conversation."

"But who would fly Santa's sled if not for a magical reindeer," said Kassandra.

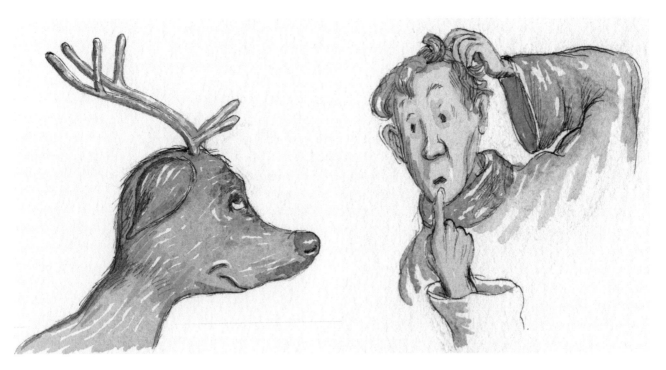

Santa looked at David and said, "It makes sense to me."

David thought to himself, "This could work." And Eddy became Santa's first magical flying reindeer.

Just as they were about to embark on their magical journey, Santa turned to David and asked, "How will I ever deliver so many toys to so many children in just one night?"

"Because Santa, as we are speaking there is an army of angels sprinkling the world with magic dust, so that this night will be extended," David assured him.

So from that day to the present, on the eve of Christmas day, the night before the most magical day of the year, Santa and his helpers fill his sled stacked full of toys, and deliver joy and toys to all the children of the world.

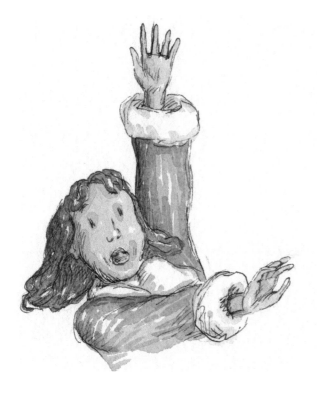

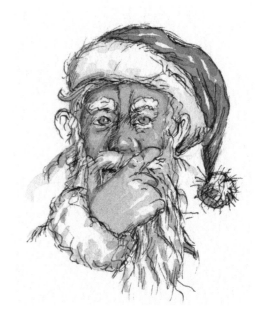

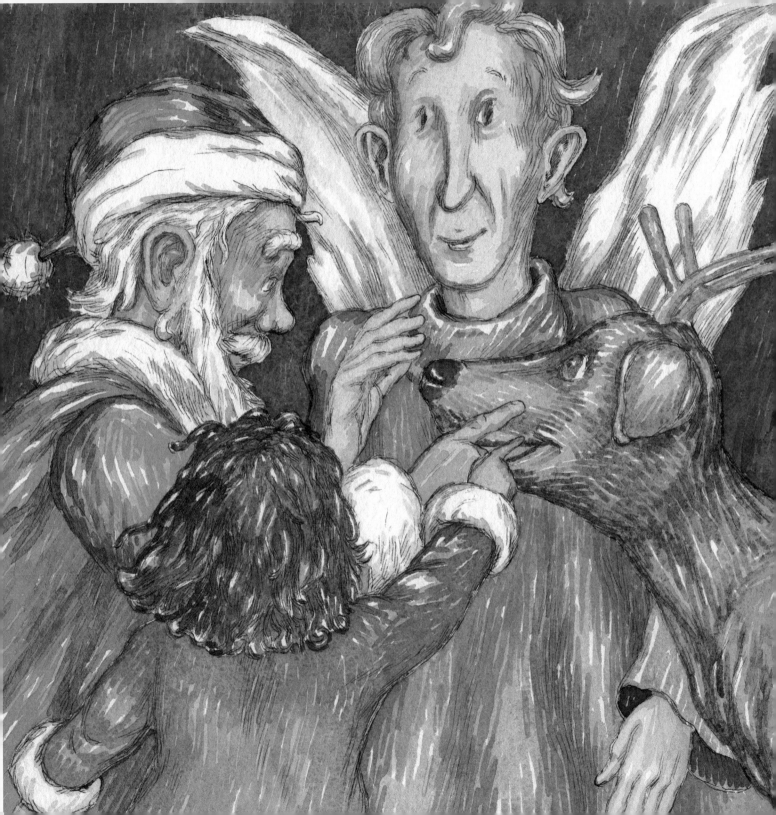

As Santa, Kassandra, and Eddy began their journey, David stood waving goodbye to his new friends. As they faded from sight, Linda appeared by his side. Sensing her presence, he turned, smiled, and asked, "Well, what's the verdict chief?"

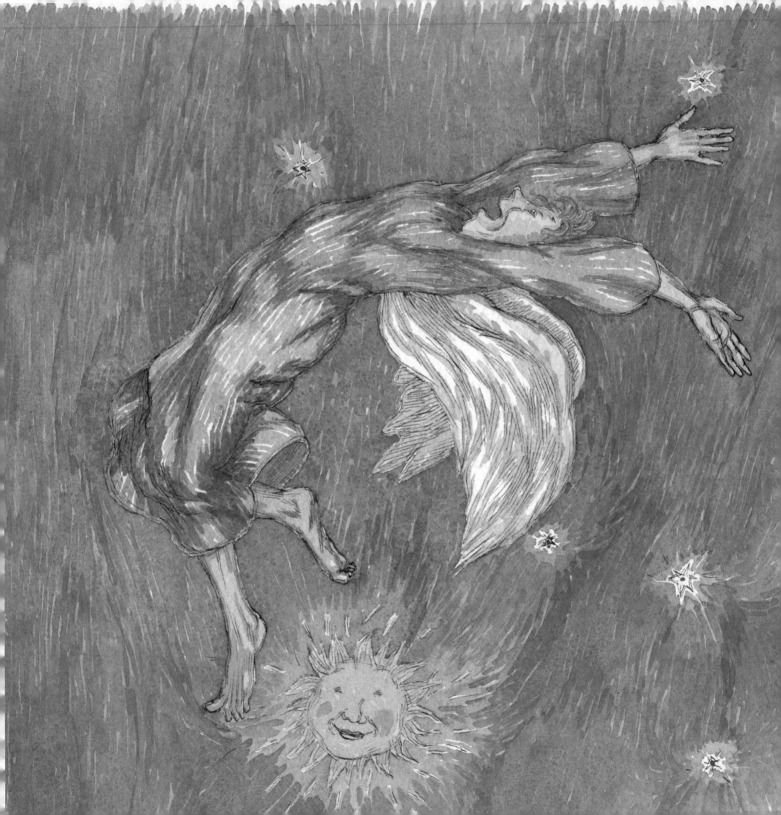

Linda gazed upon David ever so endearingly, and said, "You don't know how happy you've made me tonight, David. Thanks to you, come morning, every child will wake up to a smile."

David roared with excitement and danced with joy, "Yes! What a Christmas present!" he shouted out. For every angel knows that the greatest gift of all is to love and be loved in return.

The first thing Santa did that evening was take Kassandra home. As they approached her home, Santa noticed the look of worry on her parents faces. So he decided to land the sled on the roof quietly. He picked up Kassandra and walked her to the chimney. After making sure it was clear, Santa instructed her to climb down. As he placed her on the chimney, Eddy shouted out, "You can't do that, Santa!"

"Can't do what, Eddy?"

"Drop her down the chimney, she could fall and get hurt."

Santa decided to have Eddy fly Kassandra to her room, assured she would be safe. After that, Santa and Eddy continued their magical journey.

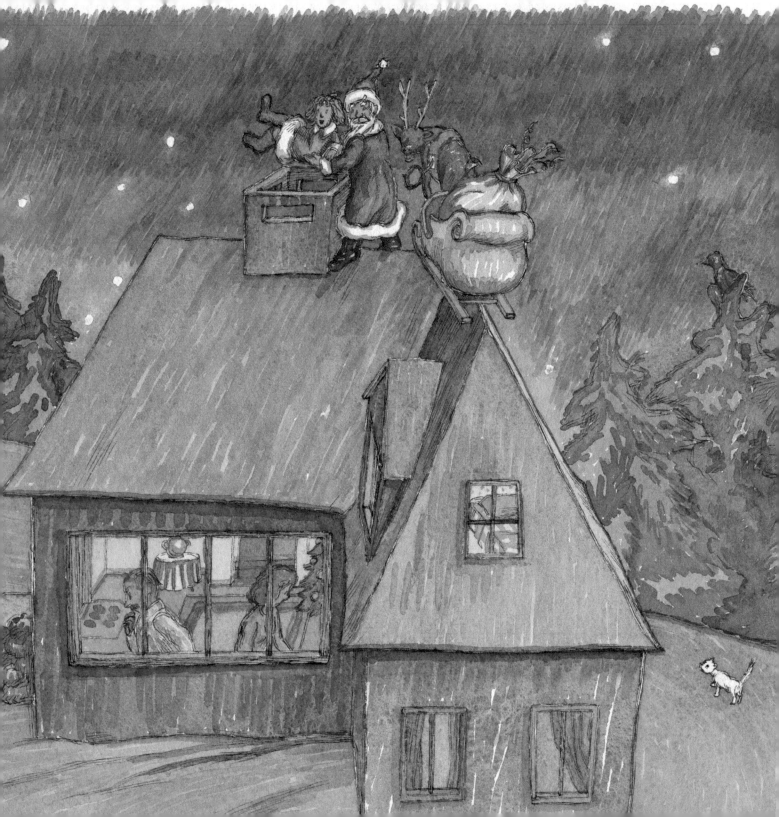

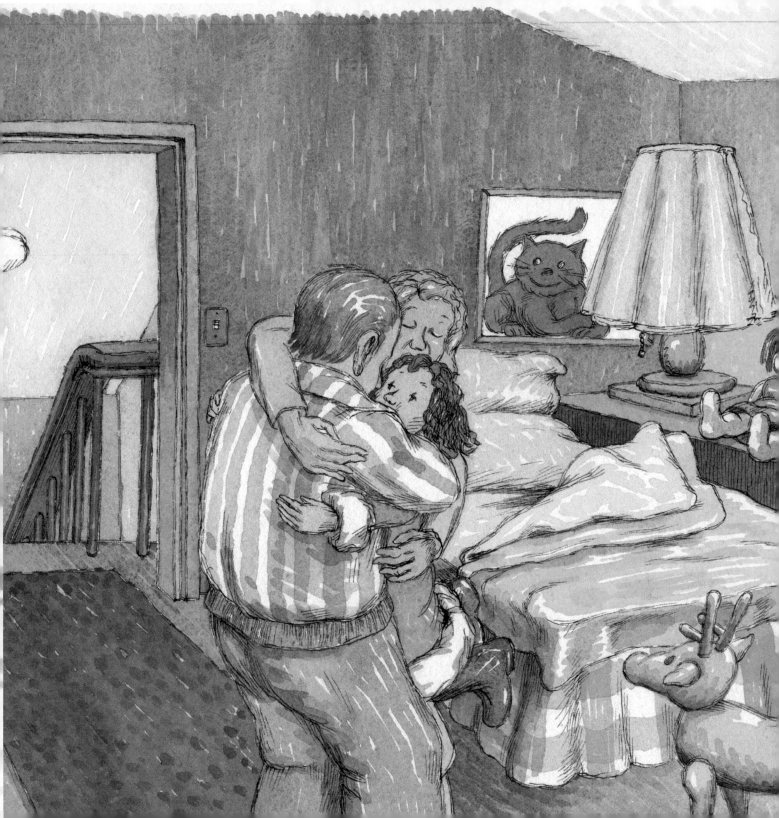

When Kassandra's parents heard her enter her room, they quickly went to investigate. When they opened the door, Kassandra was kneeling in front of her bed and praying. As they entered the room Kassandra jumped up and gave them both a great big fat hug. They asked Kassandra where she'd been.

"I was in the North Pole with Santa Claus, Eddy the flying reindeer, and an angel."

The father whispered in his wife's ear, "Maybe she was dreaming."

The mother whispered back, "Maybe she was sleepwalking."

The parents tucked her in and went to their room.

Come morning, when Kassandra woke up, the first thing she did was race to the living room. There she found a beautifully decorated tree with toys underneath it. In addition to that, there were colorfully decorated stockings hanging above the fireplace, filled with candy and other small gifts. The commotion caused by Kassandra had awoken her parents. When her parents saw Kassandra playing with her new toys, along with all of the other gifts and decorations, they did not believe their eyes. As they looked on in disbelief, Kassandra shouted out, "There really is a Santa Claus, reindeer can fly, and David is the best angel ever in the whole wide world!"

Her parents turned to face each other and said, "Now it makes sense."

And from that Christmas on, and for all Christmas' to come, all because one little girl was willing to believe in the magic of miracles; on the eve of Christmas, the night before the most magical day of the year, Santa and his reindeer embark on a magical journey delivering toys and joy to all the children of the world.

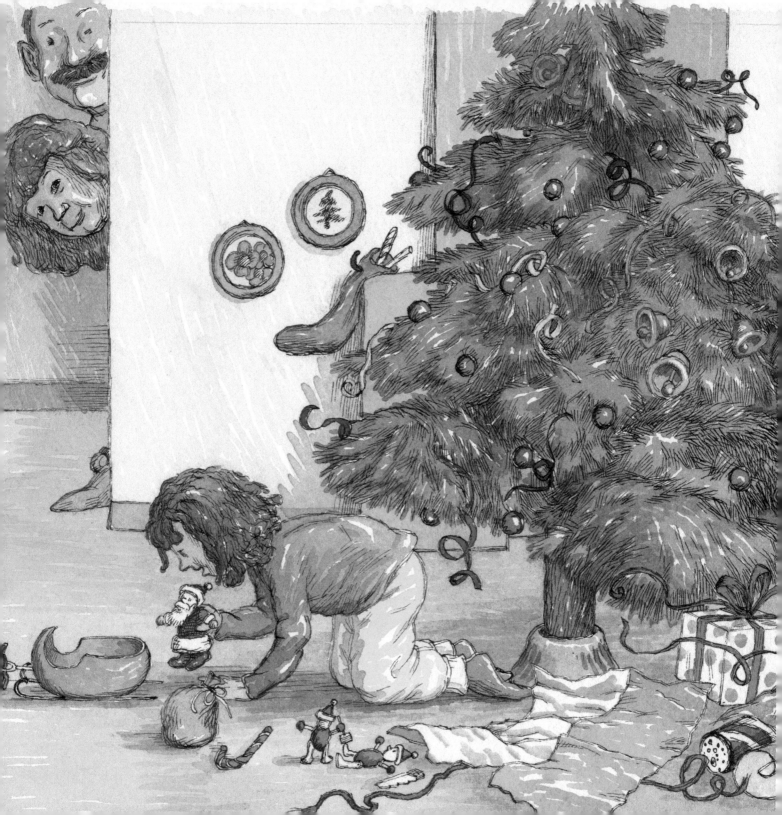

Printed in the United States
By Bookmasters